ILLINOIS WOMEN ARTISTS: THE NEW MILLENNIUM

This exhibition has been developed and is presented by
The Illinois Committee for the National Museum of Women in the Arts.

ILLINOIS WOMEN ARTISTS

THE NEW MILLENNIUM

TABLE OF CONTENTS

THE NATIONAL MUSEUM OF WOMEN IN THE ARTS

February 17, 1999

Dear Friends in Illinois,

It gives me great pleasure, on behalf of the National Museum of Women in the Arts, to extend my congratulations to the fifty artists recognized in *Illinois Women Artists: The New Millennium*. As the exhibition tours for the next two years, it will present splendid opportunities for Illinoisans to recognize and pay tribute to their own Illinois artists. The show represents some of the best art being produced in the state today. The museum's mission to recognize and honor women artists everywhere has thus been given a great boost by the hard work of the Illinois Committee for NMWA. The board and staff join me in expressing appreciation. We very much look forward to showing the work in Washington, D.C., and to our future association with the Committee.

Wilhelmina Holladay

Wilhelmina Holladay
Chair of the Board
The National Museum of Women in the Arts

1250 New York Avenue, N.W. Washington, D.C. 20005-3920
Phone: 202-783-5000 Fax: 202-393-3235 Website: http://www.nmwa.org

OFFICE OF THE GOVERNOR

GEORGE RYAN
GOVERNOR

January 22, 1999

Greetings:

As Governor of the State of Illinois, it is my pleasure to congratulate the Illinois Committee for the National Museum of Women in the Arts on the occasion of this signal exhibition honoring the creativity and vitality of Illinois women artists.

The range and richness of these artistic expressions reflect the diversity of our state, comprising many races and ethnicities. It represents small river towns, wide green prairies, and one of the world's great cities. Your talent and skill bring honor to the state of Illinois.

On behalf of the citizens of Illinois, please accept my congratulations and best wishes for much continued success.

Sincerely yours,

GEORGE H. RYAN
Governor

207 STATE CAPITOL, SPRINGFIELD, ILLINOIS 62706

As president of the Illinois Committee for the National Museum of Women in the Arts, I am delighted to introduce the exhibition, *Illinois Women Artists: The New Millennium.* It marks the successful completion of our Committee's first project, an exhibit of contemporary art by women artists in Illinois. In the past decade the National Museum of Women in the Arts has encouraged more than twenty states to form committees to help it in its mission of honoring women's contributions to all the arts and creating a greater awareness of those contributions, both past and present. Most of the State Committees have begun by organizing exhibitions by their states' women artists to be shown in the Museum in Washington and to tour in their own states. *Illinois Women Artists: The New Millennium* is our offering.

The Illinois State Committee was first organized in the late 1980s but faltered and lay dormant for five years. In late 1995 I volunteered, with NMWA's encouragement, to revive it and to present an exhibition of contemporary art by women artists in Illinois. As I worked to define a mission which would appeal to all artists and resist all labels, I asked many questions of many people. I wanted to know, What kind of art was being produced in Illinois? Would art by women be different from art by men? Was there "Chicago" art and "downstate" art? Rural art and urban art? Feminist art in the national sense or the local sense? Did categories such as "traditional," "postmodernist," etc., exist as separate entities, or was someone quietly amalgamating the past with the present? I had a deep desire to see what was out there and give it some—or in some cases, some *more*—light of day.

While developing a suitable mission, I was also learning how to develop a board. Two enthusiastic friends became secretary and treasurer. Original board members were enticed back and have remained, eager to see and participate in the results. Brenda Edgar, our then-governor's wife, resumed her place as Honorary Chairman, and Maggie Daley, wife of Mayor Richard M. Daley of Chicago, and Jeanne Simon, wife of now-retired Senator Paul Simon, joined us as Honorary Co-Chairmen, symbolizing the length and breadth of the state. The Board agreed on a juried show as opposed to a curated show. A single curator develops her own idea and then finds the art to express it. Jurors have to respond to the art that is given them. We were warned this process could be difficult, unwieldy, sloppy, discouraging to artists. But by initially letting six jurors judge slides in four regions of the state, we winnowed over 1100 entries of 411 artists down to 99 pieces. The actual pieces were then judged by Clare Henry, a veteran art critic of the Glasgow (Scotland) *Herald,* and this wonderful show emerged. It may have been difficult and unwieldy, but we feel the results were not sloppy and that we had indeed attracted a wide spectrum of artists, famous and unknown, Chicago and downstate, young and old. Not only were my questions answered to my satisfaction, but I found many more questions resolved I hadn't even thought to ask!

We had to establish parameters for the artists—our space to exhibit would have limitations, especially in Washington. We decided upon two-dimensional work (no photography) that would hang on a wall and small sculpture that would fit on a pedestal. We have had to reassure artists that we *do* consider photography an art and that we are *not* really prejudiced against big sculpture. I am sure that in the future, the Illinois Committee will give these categories their day in the sun.

Discussion at Board meetings was often lively, but the vision held, and we remained united in our ultimate mission. We wanted to do this for the artists in Illinois, and for *art itself*. And members of the public began to respond to our mission. I would particularly like to thank the NMWA members of Illinois, The Illinois Arts Council, State Farm Companies, Inc., and Mitsubishi Motor Manufacturing Company for their early support and encouragement.

My board has remained relatively small in number, with everyone ending up wearing several hats, often at the same time. We opened up our homes, bought fax machines, went on the Internet, collared friends and strangers for time and money and assistance of every kind, from providing the best of catering in Chicago to giving the president ice water when she ran dry in the middle of a speech. None of us believed in spending money we didn't have, so a lot of phone time, postage, gasoline, computer paper, as well as personal skills were donated. Our first fundraiser was a glamorous affair but lost money. Our first "Committee of 1000" member, a woman donor of $1,000, was one of our own Board members, and it was quite a while before she was joined by Rosemarie Buntrock, who renewed our faith in the willingness of women in Illinois to be substantial supporters. But no one lost heart or the ability to think up something new when the last idea didn't work. And here we are! I salute you all!

I was lucky enough not only to have a successful Board but to have two people behind me who provided third and fourth hands whenever I asked for assistance (and sometimes when I did not have the sense to ask for assistance). They deserve the credit for whatever went right and none of the blame for whatever went wrong. I am referring to my husband, Walter, and my daughter, Sylvia, my right hand man and woman. Thank you from the bottom of my heart.

There are three more people outside the Committee who deserve special thanks from me—Carol Reitan, former mayor of Normal and politician extraordinaire, who introduced me to corporate networking and fundraising; Kent Smith, Director of Art for the Illinois State Museum in Springfield, whose steady, quiet wit behind a constant stream of advice, encouragement, and assistance stiffened our resolve while lightening our hearts; and Mary-Glynn Boies, artist, educator, and computer expert, who combined those crucial talents with a calm demeanor and attention to detail that proved invaluable in our complicated jurying process. We could not have been ready to go in 1999 without these three people.

Finally, I must pay tribute to the women artists of Illinois. The encouragement I received from you let me know that we were on the right track, that this was a show with a difference and a show that needed to be done. Whether or not the artist was going to be eligible even to enter, she (and he) kept saying the same thing: "What a wonderful idea! Do it!" The results have made the visual arts a more important part of life in Illinois. You have enriched all our lives as a result. Illinois thanks you.

Charlotte Arnstein, President
The Illinois Committee for the National Museum of Women in the Arts

For twenty years I have been a professional looker, i.e., an art critic! Every year I see hundreds of exhibitions, thousands of works. As the only child of a sculptor mother and photographer father, I was taught to observe carefully, a habit I later refined as art student, teacher and printmaker. I soon discovered that some images stay in your mind, lodge themselves in your psyche. Somehow these images matter. They have conviction, integrity, sincerity—call it what you will. One does not have to like them, but somehow or other these images have a power, carry an impact. They ring true. The artist has carried out her initial idea, not just with professionalism and skill, but with that added essential and indefinable something that speaks to you, touches you.

"Once seen never forgotten" is a glib phrase, but I find that years afterwards I can recognize a special painting or sculpture. "Memorable" is perhaps too strong a word, but the spark is there and ready to ignite a fire if given a chance. These "sincere" paintings or sculptures are experiences obviously worthy of storing away in the mind, worth remembering. That criterion was at the forefront in selecting this exhibition. I did not look for any feminist viewpoint, subject, or message but purely at the formal aesthetics and the artistic conviction. It *would* have been possible to put a feminist spin on this show, but that would have compromised the quality of the work. In any case, those days are past. It is no longer necessary or sensible to play the strident feminist card. If a woman artist has something interesting to say, it inevitably forms an integral part of the fabric of her work.

Happily, I have catholic tastes so do not particularly lean towards figuration or abstraction. Today's pluralism—in both North America and Europe—is in my view a healthy thing. This Illinois New Millennium show reflects that current state of affairs and includes diverse work, from minimal conceptualism via digitalization and laser to traditional watercolors and oil paintings. It also includes three-dimensional pieces made from wax, papier maché, vellum, ceramic, limestone, perspex, and metal. I personally bemoaned the dearth of printmaking and also the lack of abstraction. However, Illinois's predilection for figuration is understandable in view of the Imagists and the Hairy Who, both movements associated specifically with Chicago.

Obviously, I came to the submissions completely fresh, knowing none of the artists, recognizing none of their personal calligraphy. I am used to being able to spot an artist's style from across a crowded gallery, so this felt rather odd at first. However, quality is universal and easy to identify. Moreover, the mix of styles and approaches was surprisingly similar to European competitions. One problem I encountered was each artist being represented by only one item. I much prefer to see a body of work, four or five pieces minimum. Here, artists had to sink or swim on the basis of a single idea.

Two artists who were obvious candidates epitomize my approach because they are so very different but unquestionably what the British call "dead certs" for the final selection: Dean and Hild. Dean's *Pin Woman* is just that: a minimal torso form made out of black wax and then covered in pins. As an object it is lovely to look at, appealing to hold. Yet more than that, its simple pared down form defined by a subtle metallic sheen has a fundamental power reminiscent of early prehistoric icons. Hild's precise narrative style—two women, one black one white, united by an op art hen, their hands

linked to form the central focus — is a million miles away in technique and treatment, yet also speaks of age-old ritual and understanding. Its title, *Grace*, can be read on several levels: grace in acceptance of our fate, be we animal or human; grace as in hope and charity — or is this bird not destined for the pot, but actually a pet affectionately called Grace! In one way these works say little that is overtly female, especially in contrast to Paul's modern Madonna and Child or Bladholm's *Pandora*, but they hint at the natural paradoxes of female life with all the strength and vulnerability that each woman experiences.

There is yet more ambiguity in Altenhofen's *20 Replies Not Yet Sent* and Holz's *Leaf Writings*, both pieces using indecipherable text, a paradox in itself, as writing is for communication. Altenhofen's two-part wall piece made from the casts of dolls' arms includes one section where letters written in Italian are collaged onto the limbs. Holz scratches her script into the layered surface of her picture. Both hint at love and loss, distance and separation.

Another wall piece, Shaughnessy's *Mini Mutants,* pokes fun at the serious topic of cloning by putting Barbie's head on Bambi's body to create monster toys caged on a supermarket peg board display. More caged creatures appear in Wolfram's altogether more sinister painting, where muzzled women in 19th Century period costume are led like tame animals or pets by men made vulnerable by their own nakedness. These relationships forged in Hell create another paradox, a further mystery. In contrast, some artists use oil paint purely for the pleasure of it, such as Thienemann, whose *Dry Dock* evokes powerful two-dimensional sculpted geometry. Others employ watercolor to delineate with old fashioned precision, as exemplified by Meyer and Capps. Good draftsmanship is always welcome, so I was happy to select Roth's *The Dance,* drawn with an honest eye; also, Lehrer's self portrait. Illness was a topic faced head-on in totally different ways by Sigler and Wonsil, while surrealism made a rare appearance under Nilsson's imaginative touch.

While selecting the show, I was asked if the theme, The New Millennium, fit the artworks. In as much as art inevitably reflects the period in which it is created, the answer had to be yes. But in fact, trying to contrive a false theme or ethos is nonsense. In reality, Millennium applies to the title of the show rather than the content. Artists develop in their own way, according to their own individuality. They are brave people who bare their souls, put their beliefs on the line. Artists create the energy that fuels our culture. More and more, maybe because of TV and film, the image is in the ascendancy. It has a universal — and powerful — impact. Artists are becoming more, not less, essential, but it's still a lonely path. We viewers merely partake of an often long and excruciating, but always unique, creativity.

To prove the point, right at the end I wickedly selected Kim's cool, clinical, black and white minimal squares to hang next to Youngquist's bejewelled, kitsch *Flight of the Zebra*. Poles apart, they represent the joy of the nonpareil! I much enjoyed selecting the Illinois New Millennium exhibition. It proved to me above all else that, despite fashionable "isms," individuality is here to stay.

Clare Henry, Final Juror
Art Critic, *The Herald* (Glasgow, Scotland)

ANGELA ALTENHOFEN

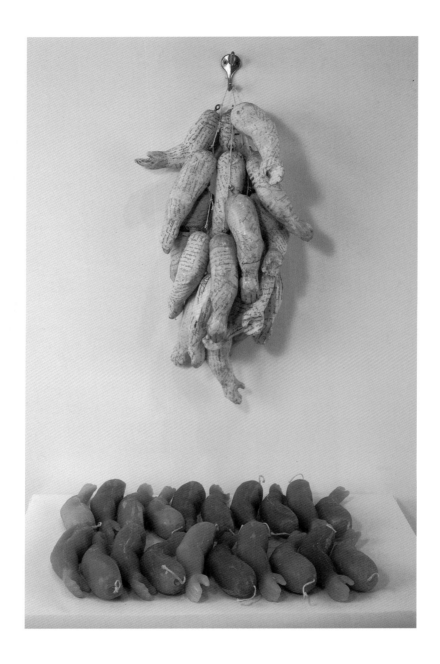

20 Replies Not Yet Sent
6.5" x 2" each
cast papier maché, beeswax, decoupage letters

BARBARA BLADES

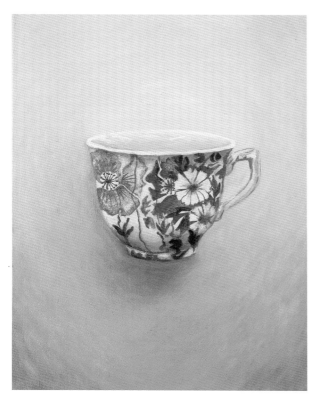 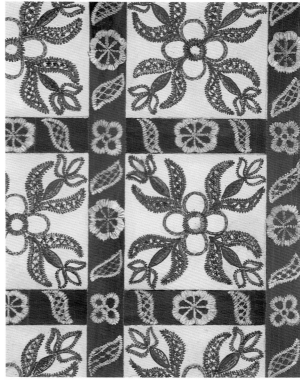

Fragments #29 and #30
12" x 9" each
acrylic on panel

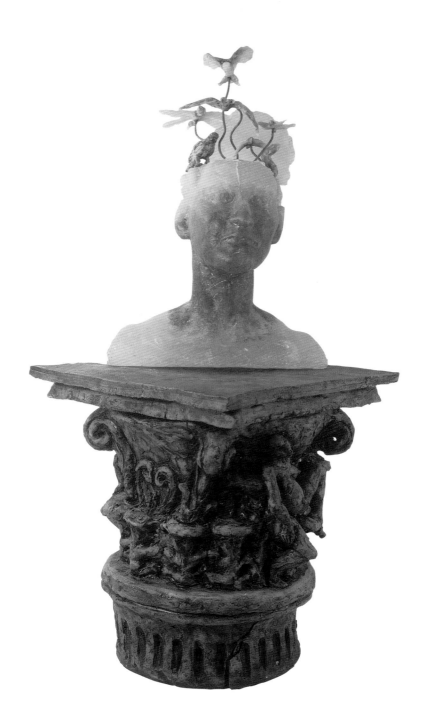

Pandora's Dilemma
35" x 14" x 14.5"
cast glass, ceramic, wax, natural materials

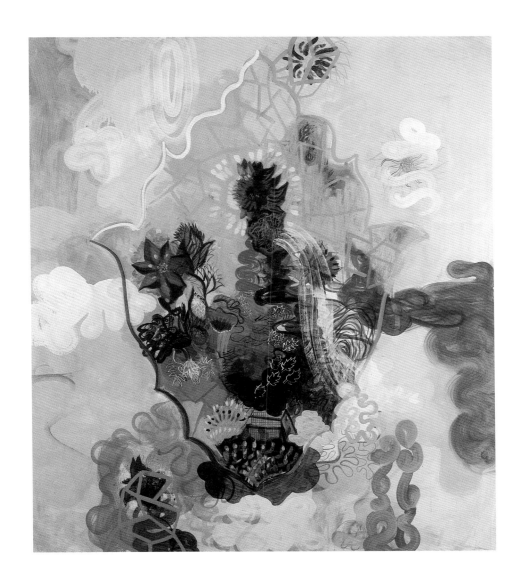

Flora Bunda
60" x 44"
oil on canvas

SARAH CAPPS

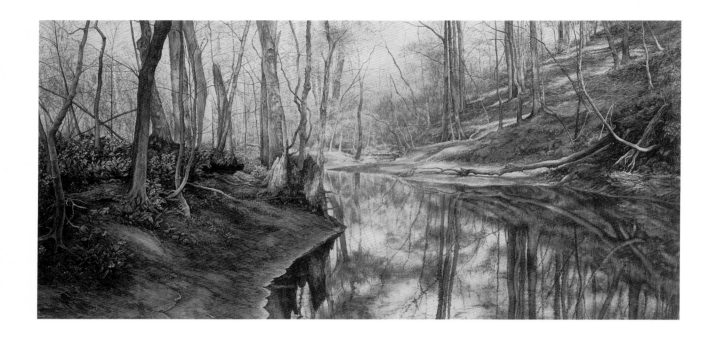

Awakening
23" x 38"
watercolor

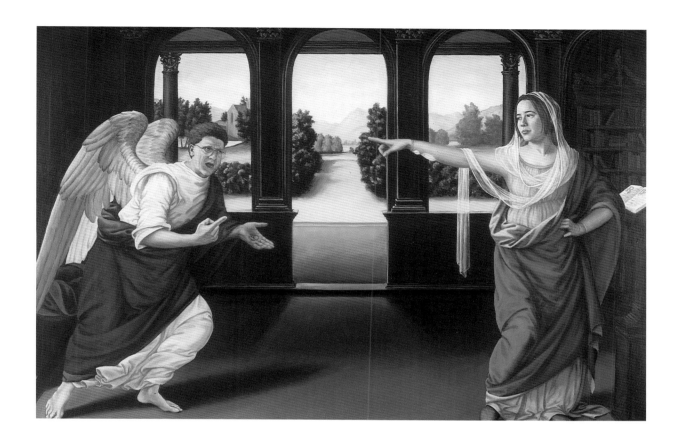

The Annunciation
24" x 36"
oil on canvas

JAN DEAN

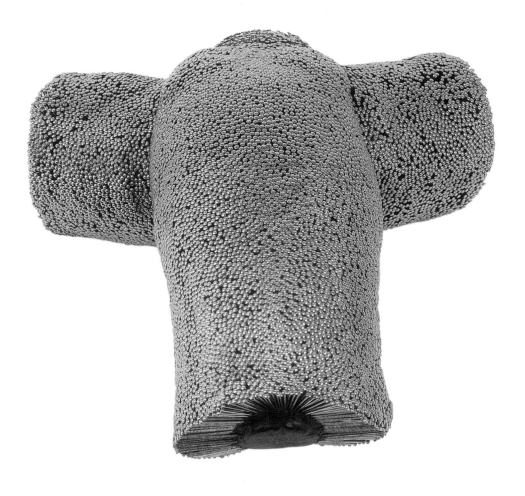

Extra Super Heavy Duty Plated Rust Resistant Steel Pin Woman
7" x 6" x 3"
wax, pins

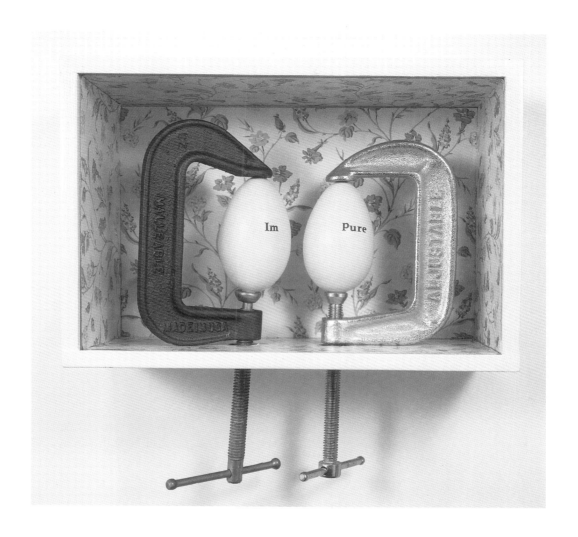

MARY DRITSCHEL

I'm Pure
10" x 7" x 5"
wood, c-clamps, presstype, paper

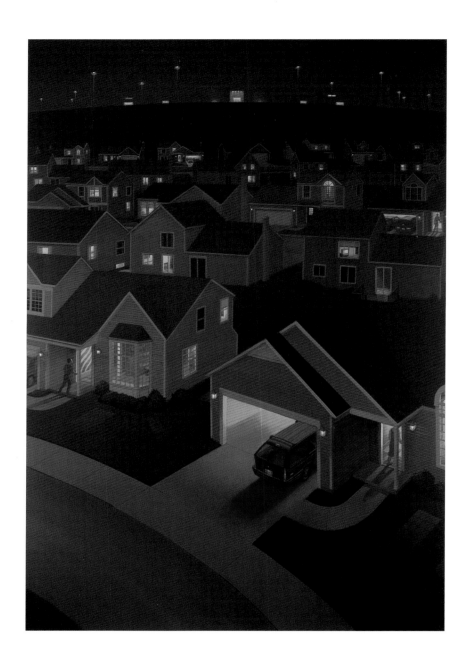

The Mall
44" x 30"
oil on canvas

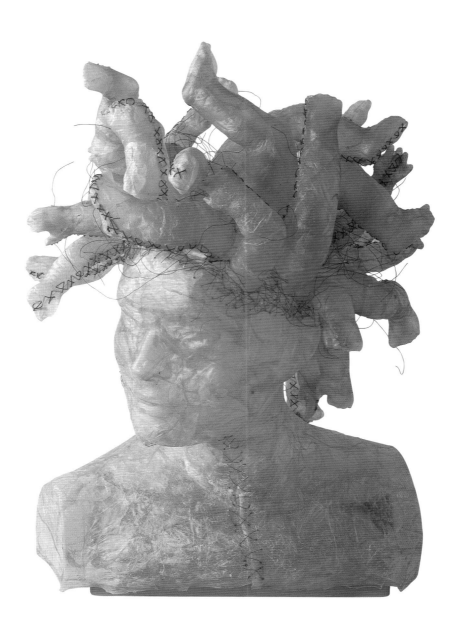

Medusa: Mother Love
19.5" x 12" x 12"
gut, steel wire, thread

JANE FREY

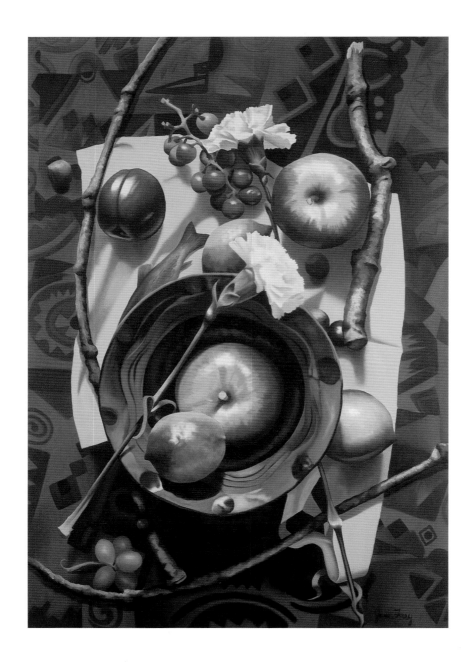

Blue Bowl 2
26" x 38"
oil on canvas

DEBRA GRALL

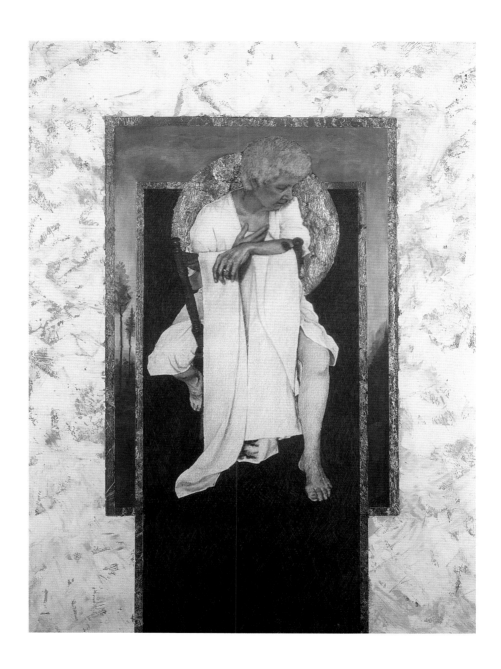

Contemplate
22" x 30"
goldleaf, gouache, prismacolor, laser transfer

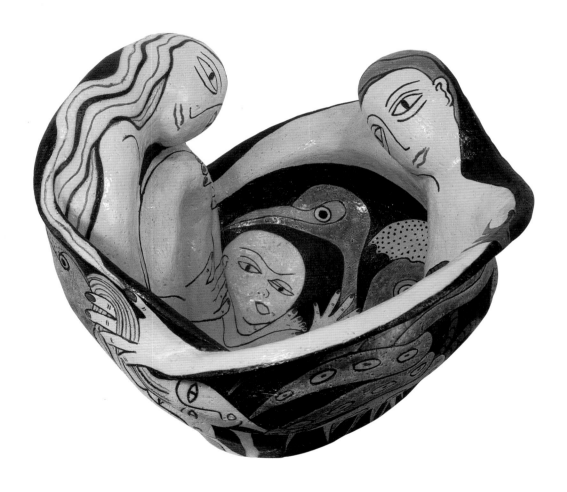

The Chicken and the Egg
18" x 24" x 23"
clay

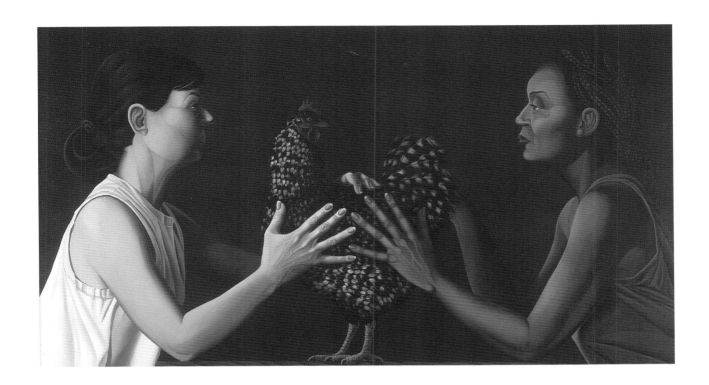

Grace
26" x 46"
acrylic on canvas

LESLIE HIRSHFIELD

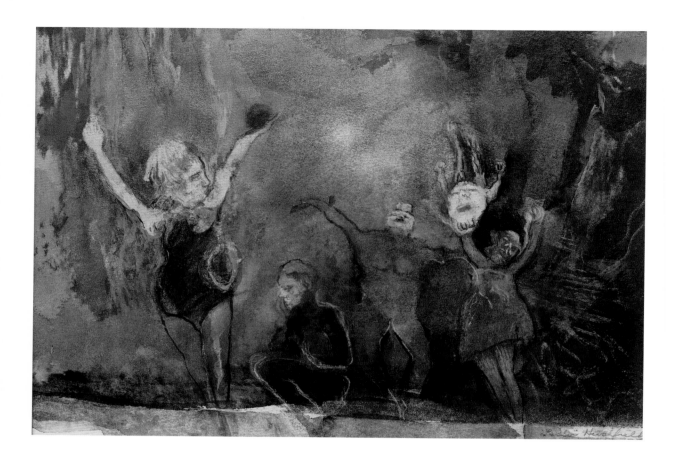

Overture
11.5" x 14.5"
ink, gouache, lithograph

26

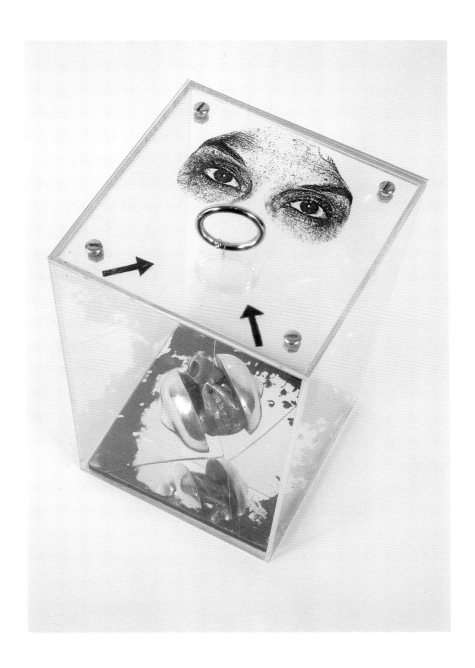

Self Portrait
13.5" x 8" x 8"
plexi box, cast aluminum, photos

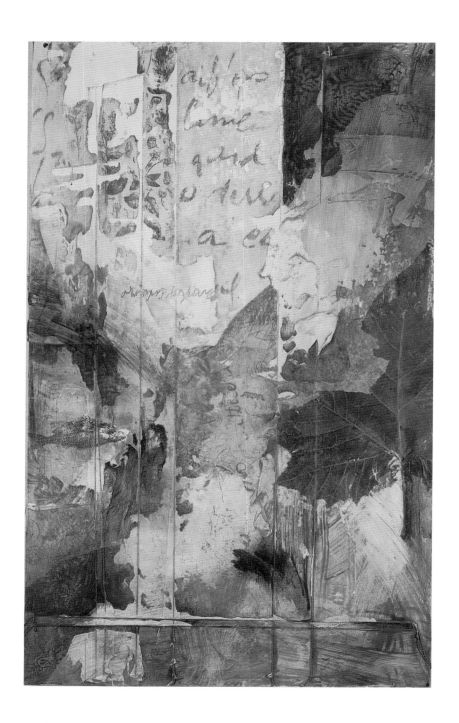

Leaf Writings
18" x 29"
mixed media

CHEONAE KIM

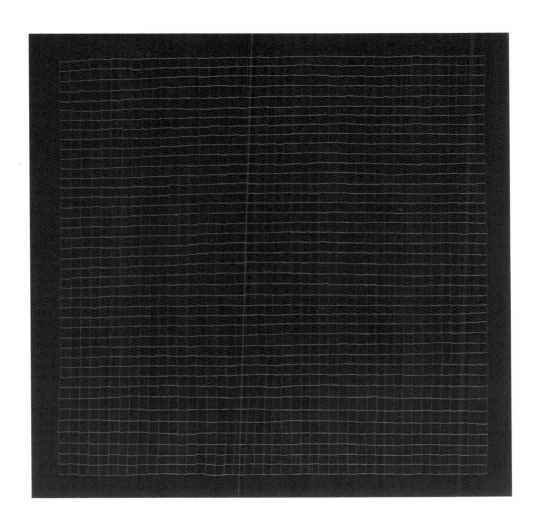

Untitled 1998
5" x 5"
acrylic and graphite on canvas

JAMIE KRUIDENIER

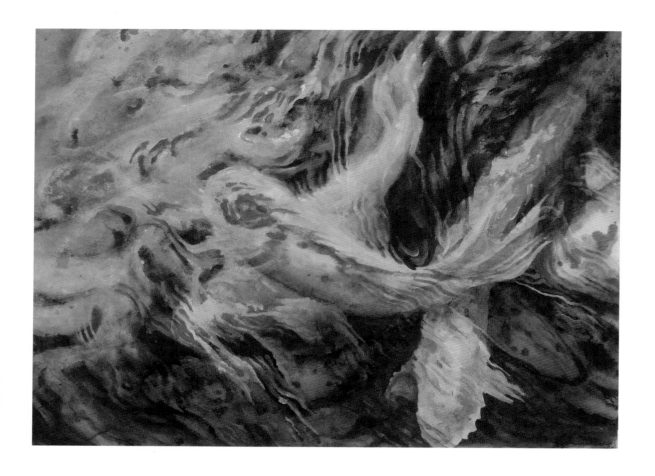

Carpe Diem
25" x 36"
casein on rice paper

RIVA LEHRER

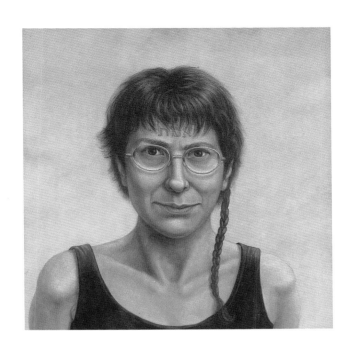

Artist's note:
In normal installation
there is a three-foot
vertical gap between
head and feet.

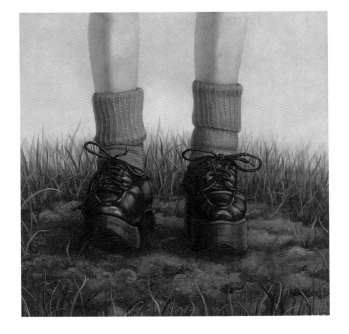

Circle Story #4: Self Portrait
(diptych)
14" x 14" each
mixed media on paper

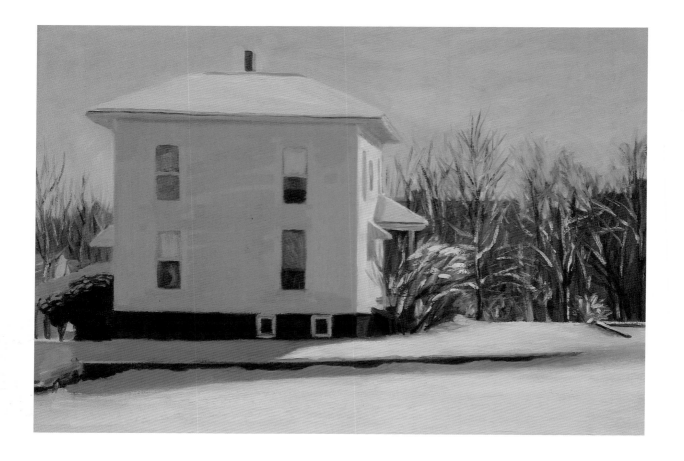

White House, Snow
14" x 20"
oil on canvas

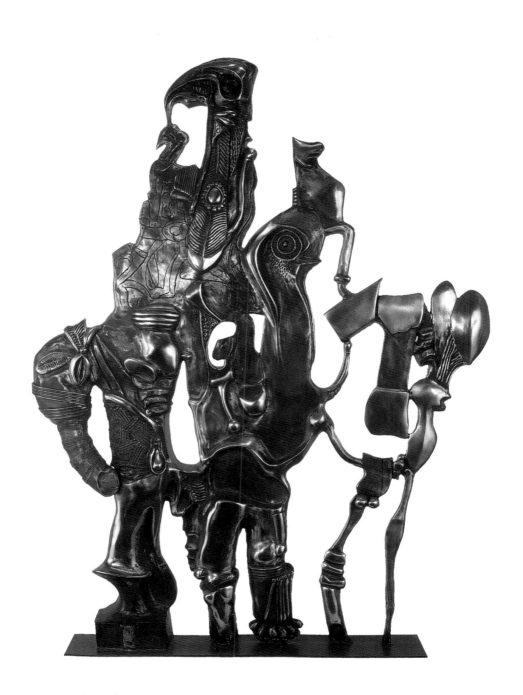

Ancestral Parade II
40" x 32" x 6"
bronze

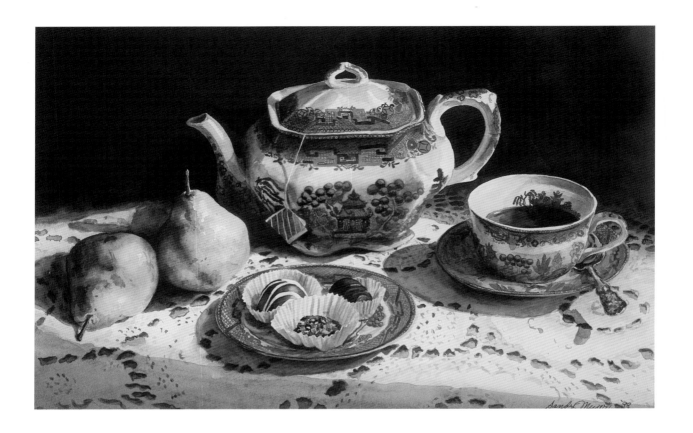

Spot of Tea
21" x 27"
watercolor

34

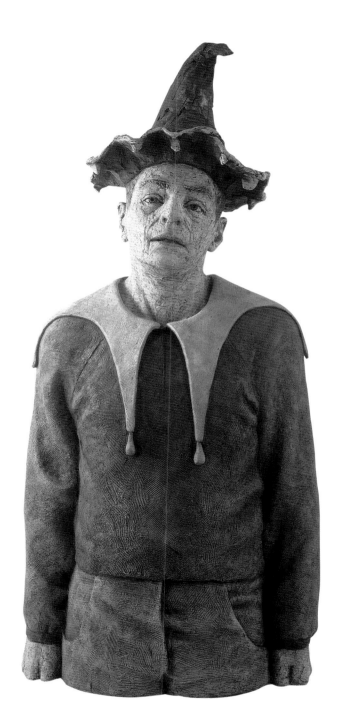

Jester
37" x 17.5" x 12"
mixed-media ceramic

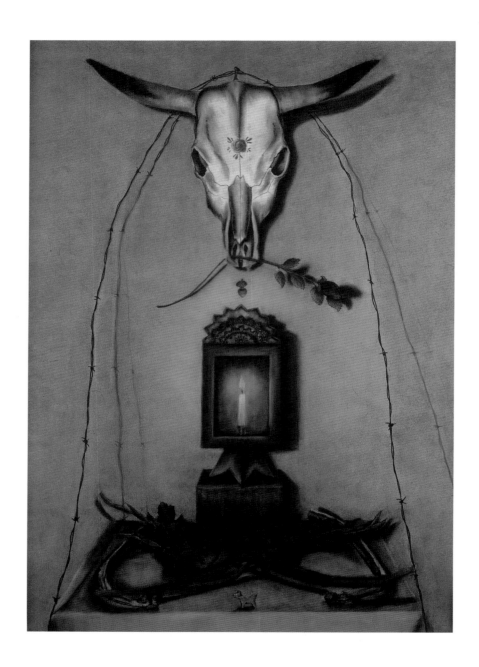

Mexico
54" x 38"
pastel and charcoal

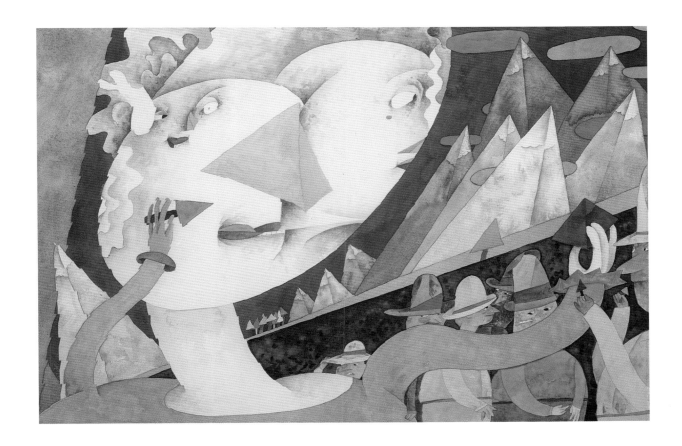

Moving Mountains
15" x 22.25"
watercolor and gouache

VALIA OLIVER

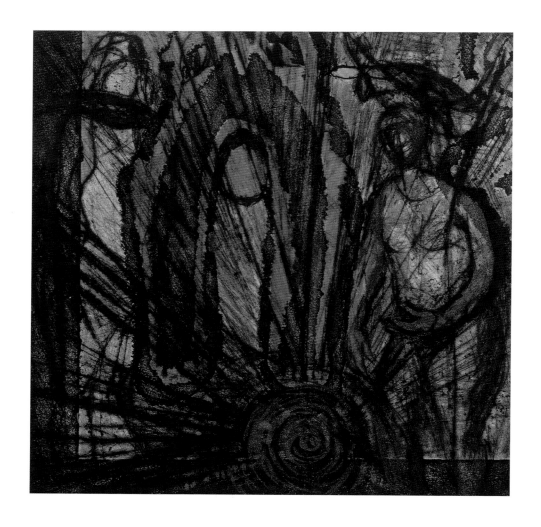

Bone Woman — Episode 2
6" x 6"
hand-colored drypoint

ERIN PALMER

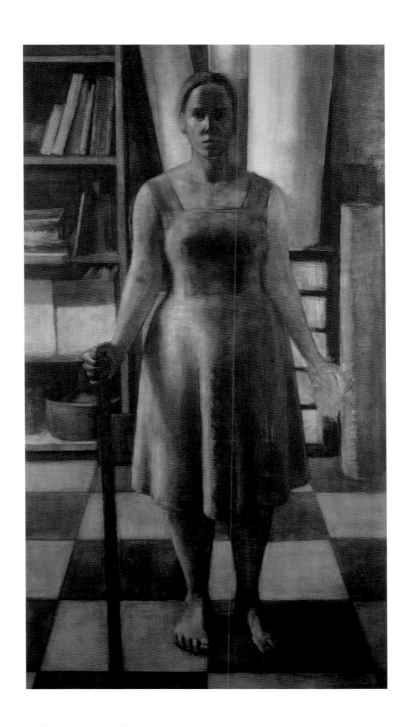

Self Portrait in Studio
72" x 39"
oil on canvas

LAUREL JENSEN PAUL

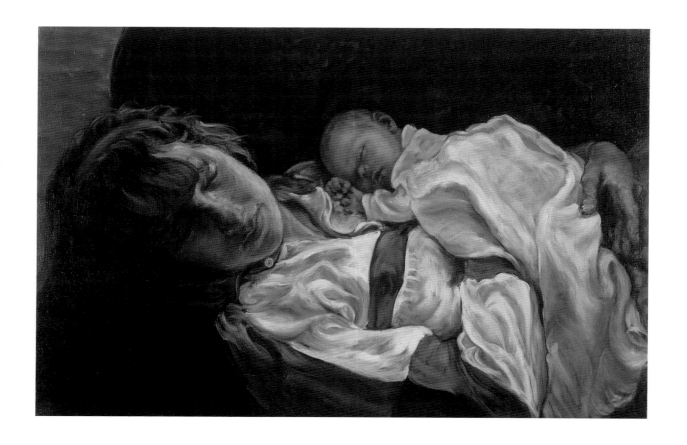

The Second Day
20" x 30"
oil on canvas

BARBARA PIHOS

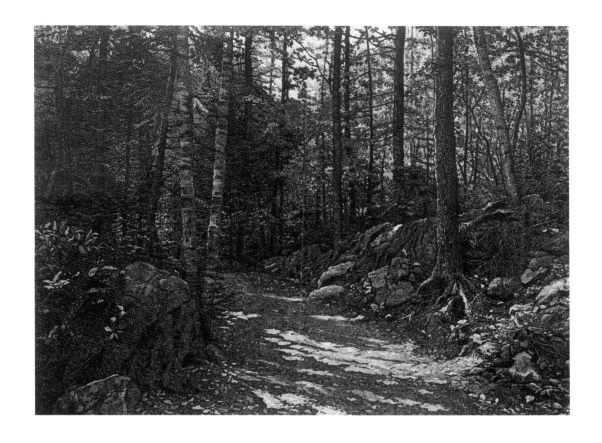

Forest Memory
9" x 12"
etching

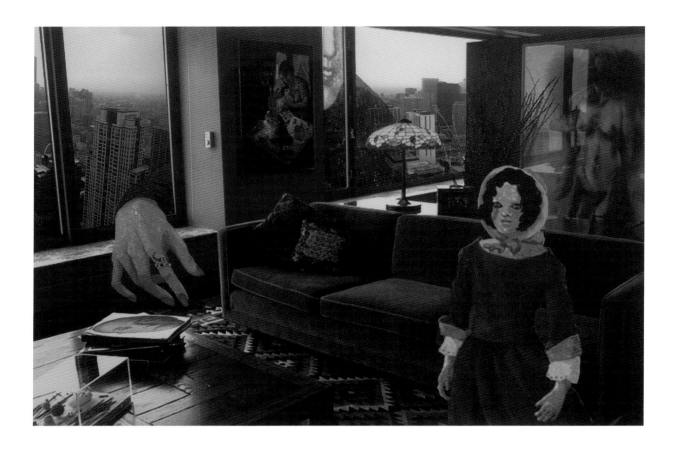

Room with Doll
8" x 12"
digital iris print

JUDITH ROTH

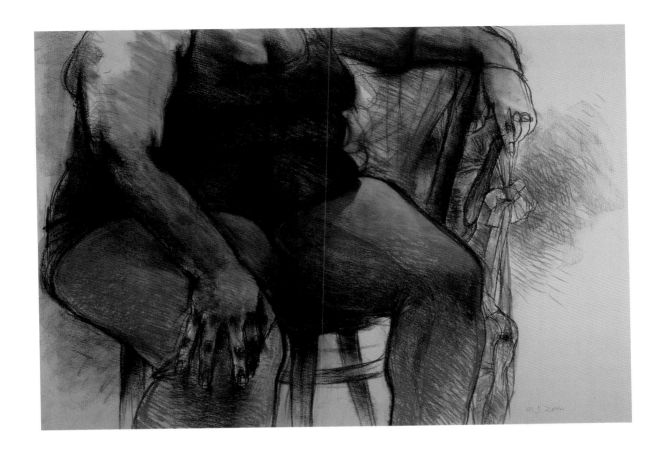

The Dance
30" x 41"
pastel

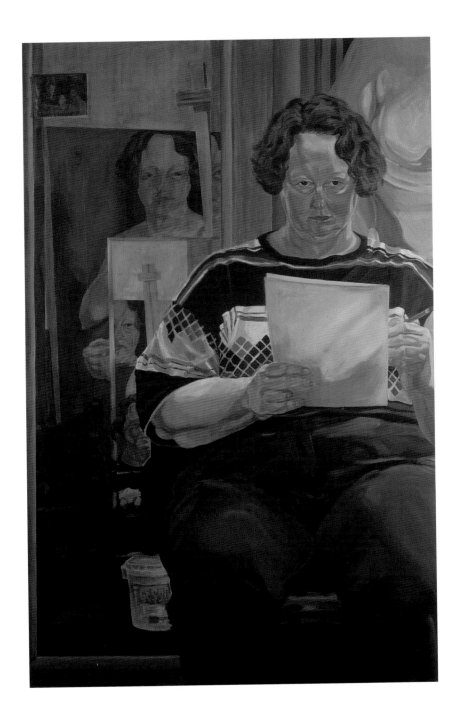

Self Portrait Double Mirror
72" x 46.75"
acrylic on canvas

DEBORA L. SENO

Red River
8" x 8"
colligraph

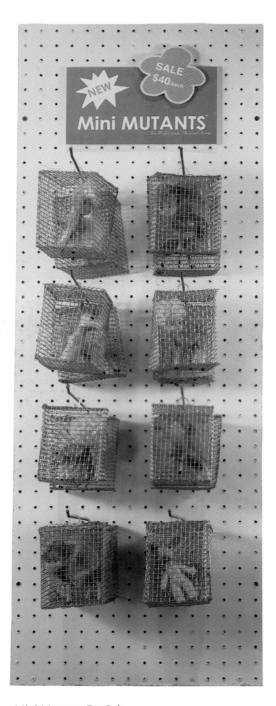

Mini Mutants For Sale
48" x 30" x 12"
peg board, paint, wood, metal, plastic doll, animal parts, paper

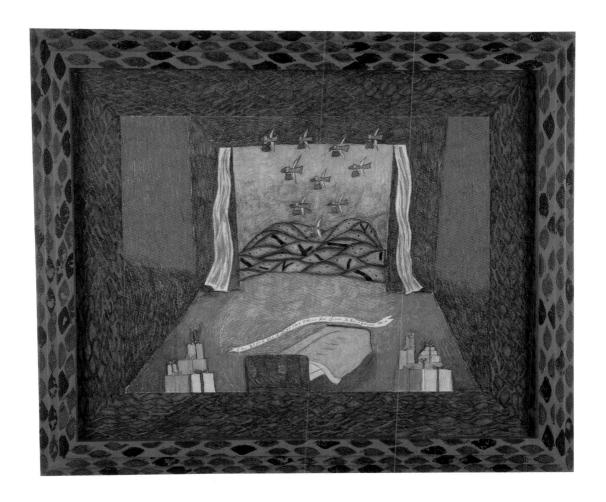

The Blood Was a Gift...
39" x 24"
oil pastel on paper

CINDY SMITH

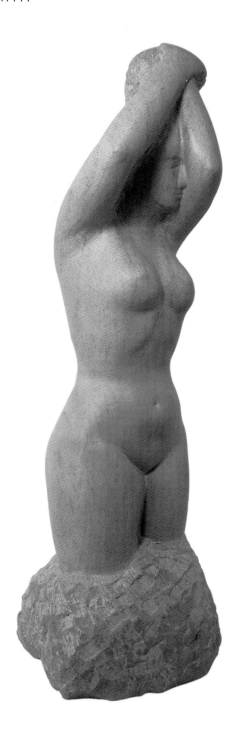

Woman
27.5" x 8" x 8"
limestone

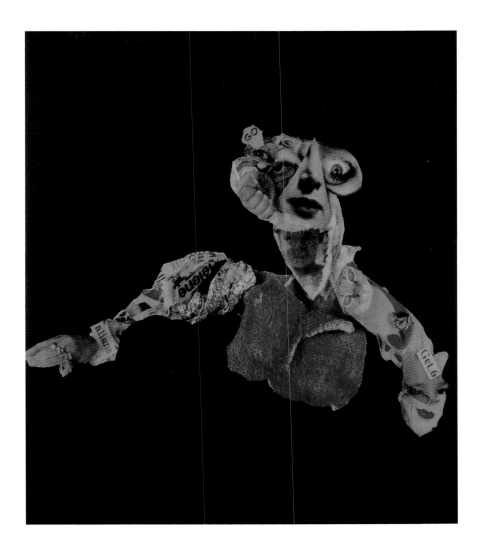

Get G
5" x 7"
computer-generated collage

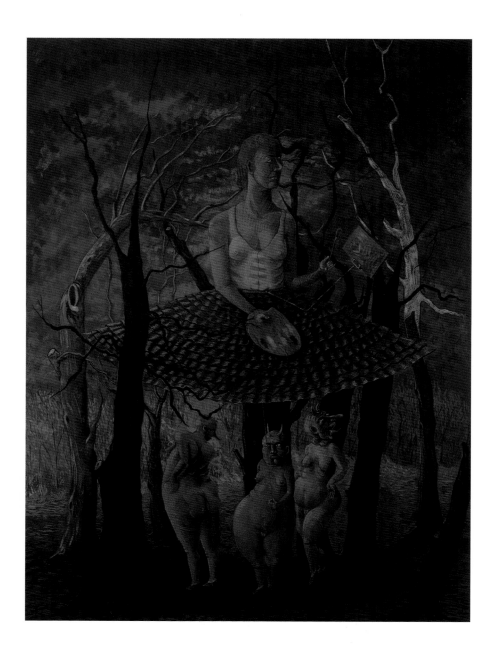

Spring Painting
30" x 22"
gouache

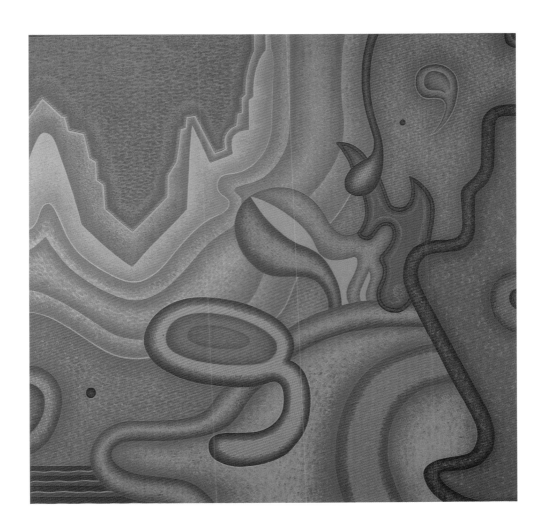

Shore Line Drive
36" x 36"
oil on canvas

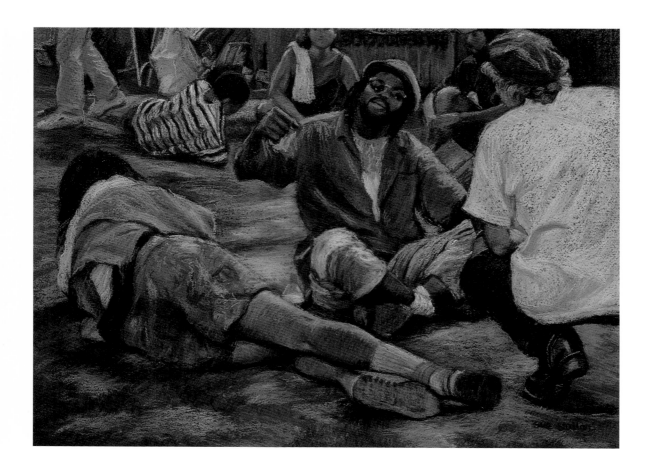

Good Times
30" x 36"
pastel

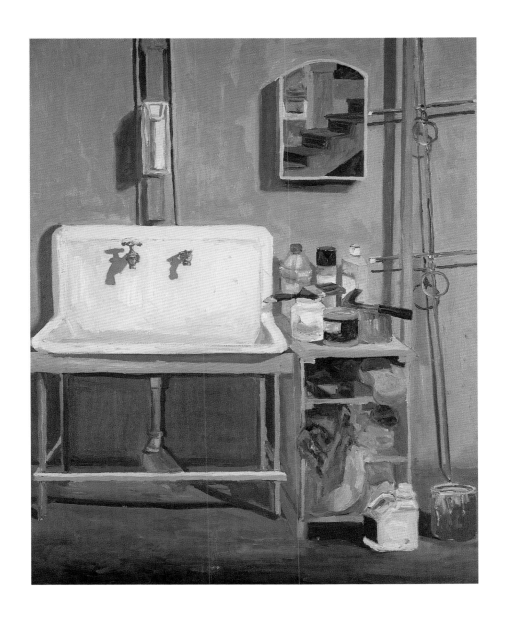

Sink
16" x 20"
oil on canvas

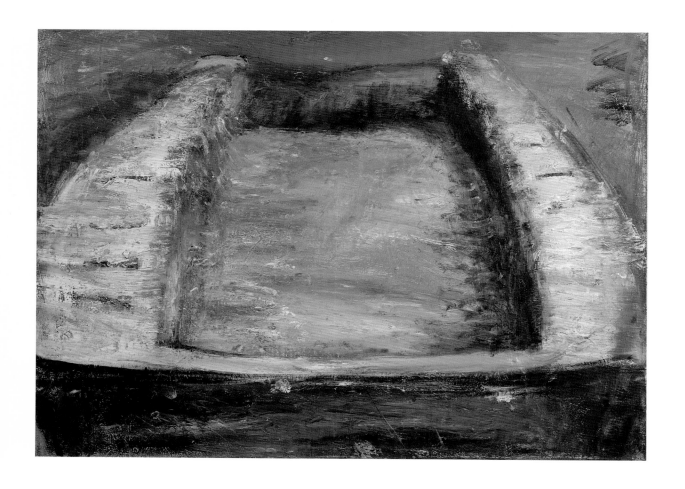

Dry Dock
36" x 48"
oil on canvas

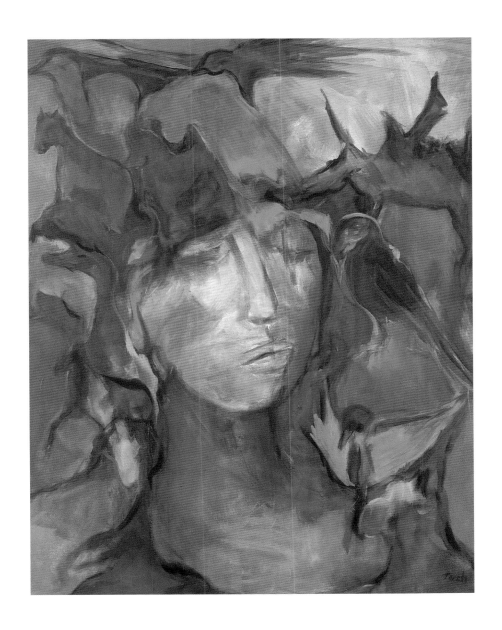

Knowledge
24" x 30"
acrylic on canvas

LAURA WASILOWSKI

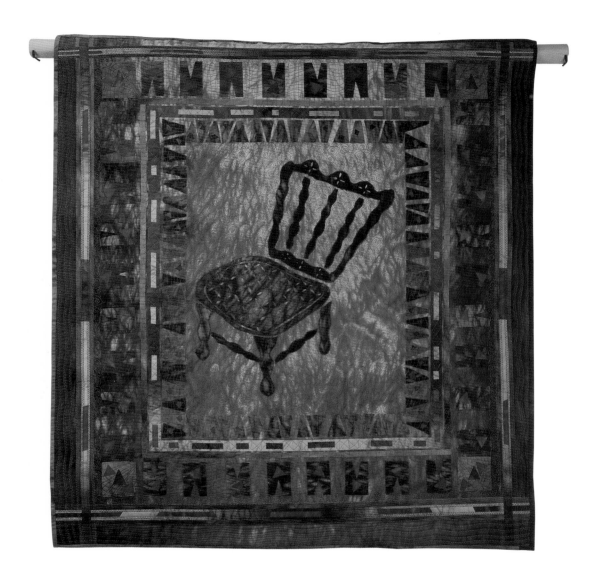

Green Chair
46" x 45"
art quilt

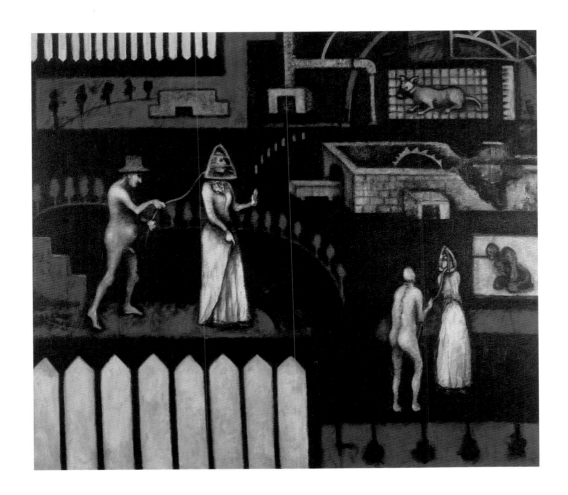

Branks
36" x 40"
oil on canvas

SIGRID WONSIL

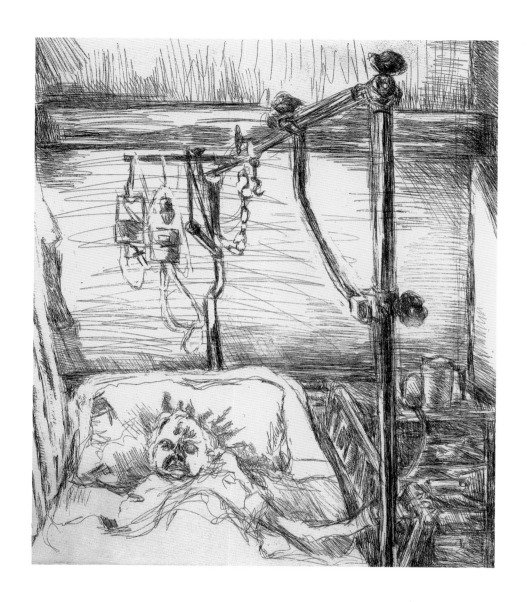

Last Illness
20" x 22"
etching

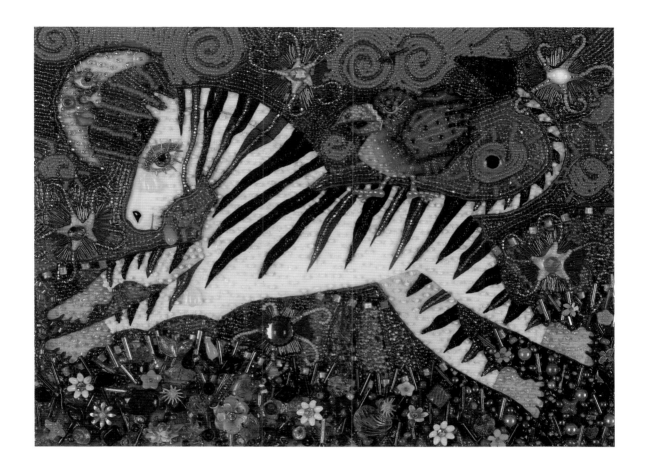

Flight of the Zebra
14" x 18"
mixed-media beaded painting

FINALISTS

Jeanine Abels
Bloomington

*Angela Altenhofen
Chicago

Paula Aronson
Cobden

Valerie Beller
Chicago

Dorothea Bilder
DeKalb

*Barbara Blades
Evanston

*Sharon Bladholm
Chicago

*Deborah Boardman
Chicago

Eileen Brandt
Glen Ellyn

Melissa Carstens
Marion

*Sarah Capps
Belle Rive

*Mary Ellen Croteau
Chicago

Diane Rose Dalling
Rockford

*Jan Dean
Chicago

Ingrid N. Dohm
Rockford

Carol Dolan
Richton Parks

*Mary Dritschel
Chicago

*Kathleen Eaton
Sleepy Hollow

Roberta Elliott
Cobden

*Gail Elwell
Murphysboro

Deborah Fell
Urbana

Sue Ferguson
Jacksonville

*Jane Frey
Taylorville

Judith Geichman
Chicago

*Debra Grall
Rochelle

Elizabeth A. Harbour
Oak Park

*Annelies Heijnen
Mt. Vernon

*Nancy Hild
Chicago

*Leslie Hirshfield
Evanston

*Pearl Hirshfield
Evanston

*Cheryl Holz
Aurora

Diane J. Huff
Barrington

Sandra Hynds
Champaign

Lorena Johnson
Champaign

Marva Pitchford Jolly
Chicago

Katie Kahn
Chicago

Julie Kiefer-Bell
DeKalb

*Cheonae Kim
Murphysboro

Mary Jane K. Kirkwood
Barrington

Claire Wolf Krantz
Chicago

*Jamie Kruidenier
Champaign

*Riva Lehrer
Chicago

Stacy Ashton Lotz
Galesburg

Julie Seregny Mahoney
Macomb

*Carla Markwart
Galesburg

Brenda Webster McCollum
Benton

*Geraldine McCullough
Oak Park

*Sandy Meyer
Quincy

*Marlene Miller
Washington

*Kit Morice
Charleston

Deborah Newton
Rockford

***Gladys Nilsson**
Wilmette

Laura O'Donnell
Urbana

Therese O'Halloran
Bloomington

Heidi O'Neill
Chicago

Sheila Oettinger
Skokie

***Valia Oliver**
Carbondale

Agnes E. Pal
Glen Carbon

***Erin Palmer**
Carbondale

***Laurel Jensen Paul**
Washington

Sandra Perlow
Chicago

Corinne D. Peterson
Chicago

***Barbara Pihos**
Hampshire

Kimberly Piotrowski
Chicago

Nancy Plotkin
Chicago

Michelle Powers
Decatur

***Claire Prussian**
Chicago

Joyce Rebora
Chicago

Doris Roberts
Centralia

***Judith Roth**
Chicago

***Jeanine Coupe Ryding**
Evanston

Arkube Kimbei Sadlon
Rockford

***Barbara Santucci**
Rockford

Gloria Ann Schabb
Bloomington

***Davida Schulman**
Northbrook

***Debora L. Seno**
Cherry Valley

***Katherine Shaughnessy**
Chicago

Elizabeth Gore Shreve
Chicago

***Hollis Sigler**
Chicago

***Cindy Smith**
Mahomet

***Helene Smith-Romer**
Chicago

R. June Snell
Auburn

Sue Sommers
Evanston

Peg Sowle
Rockford

Marla A. Spargur
Kankakee

***Eleanor Spiess-Ferris**
Chicago

***Evelyn Statsinger**
Chicago

***Sue Stotlar**
Benton

Mary Strasevicius
Hinsdale

***Naomi Sugino**
Charleston

***Maggie Thienemann**
Rockford

***Barbara P. Tuch**
Highland Park

***Laura Wasilowski**
Elgin

Margaret Wharton
Glenview

Bernie White-Hatcher
Rochester

Megan Williamson
Chicago

***Rebecca Wolfram**
Chicago

***Sigrid Wonsil**
Streamwood

***Betsy Youngquist**
Rockford

*in the exhibition

Margot McMahon
Cook County Region

One of the recurring themes of this exhibition is the use of the human form for interpretation and expression of ideas. I have worked with the figure and organic form since graduate school in the mid-1980s, where conceptual work was the predominant mode and the figure thought of as a separate art form from sculpture. Then, while teaching and creating gallery exhibits, I found it increasingly challenging to incorporate conceptual and figurative ideas. Now that we are in the late nineties, I am pleased to find such thought-provoking and skillful interpretations of the figure in this exhibition. The art world accepts the figure both standing alone and as an element of conceptual art. This process has evolved, and artists have found many unique and intriguing solutions to the problem of making a personal statement while responding to the conversations of the art world. Interpreting the complexities of the human form challenges artists of many eras, and I am glad to see so many skilled and intelligent artists working in a figurative contemporary vision.

Diverse, thoughtful, and provocative, this gathering of meaningful and brave art shows mature individual statements created with an awareness of the rhythms of the art world. Skillful modeling of figures in clay; casting in glass, wax or bronze or kiln firing; and drawing in pastels and pencil and painting in oils are just some of the ways that diverse media have been used to create images for this exhibition. For the more conceptually oriented, pins, pink fur and doll parts are formed into torsos and fused into life-forms. Abstracted forms based on nature, psychological insights, and cultural or ancestral references emerge when diverse visual symbols converge with the artists' integrity, commitment to quality, and skillful handling of materials. Also reassuring is that these works are extending the parameters of the art world and reaching out to society by embracing the universal interpretive vocabulary of humanity. This exhibition has enticing objects of wonder that can work their magic and sharpen our vision of who we are and are becoming.

Isobel Neal
Cook County Region

In this exhibition of women artists from Illinois you will find almost all possible variations in style, form, subject matter, and media—from realism to surrealism, figurative to abstract expressionism, two-dimensional work and sculpted forms.

The question is whether the artist is exploring time, form or culture. We are forced to slow down, to look, to discover what is being explored or perhaps even what is being hidden. The artist offers a new perspective of viewing the world—a new way of thinking about the world and, in some, transformation of the ordinary. If the visual arts transform by the power of "seeing," we have to learn how to "look." In many of the artists' works we found surrealistic "eyes" staring at us from the canvas. Perhaps that's the message or point to be found—whether it confirms a sense of beauty or conjures up images from long ago in some new form. Some works inform us of universal truths or evoke an emotional response— others may even look at some hard reality of life.

Do take the time to enjoy these many fine works by Illinois women artists. It was a pleasure and an honor to have been a juror.

Susan Sensemann
Cook County Region

Looking at work by more than two hundred and twenty artists from the greater Chicago area was both a challenge and a pleasure. As slides of paintings, drawings, prints, and sculpture flashed by in a darkened room, I was aware of the enormity of the project at hand. A few artists would be selected from four regions of the state of Illinois to have work juried a second time for possible inclusion in an exhibition that would travel to Washington and to a number of locations throughout the state. Within particular media and size limitations, the art selected should represent the very best contemporary art by women of Illinois. We began the review process with hopeful expectations that the prospectus for *Illinois Women Artists: The New Millennium* had reached artists of substance and quality.

In jurying work, I look for a strong concept, a unique "take" on a particular subject, and craft that is inherent to the idea of the piece. It should be without saying that slides must be presented professionally and that one's idea is best represented through a body of work that is dynamic in its clarity and coherence. Without a strong and distinctive approach to a particular subject, the slides blink by with hundreds of others. I saw, however, work that called me back for a second, third, and fourth look, work that captured my imagination and curiosity, work that stood out from the thousands of flashes of light on a screen. Subject matter ranged from figuration to abstraction, colors were muted or saturated, detail was rendered with precision or was nonexistent within an oscillating field, and wit provoked a laugh or a meditative approach caused a quiet in-take of breath.

I am interested in feeling a bit of that which causes a particular artist to go into the studio every day, to wake up in the morning and begin to pull ideas into focus, to ask questions that might take a lifetime to answer. I want to sense the ideas that an artist considers as she works with inert materials: pigment, plastic, wool or wood. I want to question why she pushes and pulls her materials into a particular form: drilling, gluing, twisting, scumbling, or patting a surface. A piece of work may be conceived with text or exist as a manifestation of a physical act; smart art takes many forms. In viewing submissions to this exhibition, I was reminded of the range of observations that women make about their experiences in the world. Intimacy, subjective intent, objective analysis, and speculation form investigations that are revealed through intelligent visual output. The artists in this exhibition offer to viewers a life's look at issues that provoke responses and suggest breadth and depth.

Tom Heflin
Northern Region
As I viewed the slides of art work, I couldn't help but think of how different the art world is today compared to the not so distant past. Women were either not painting, or not taken seriously by the male dominated art scene. I would hazard a guess that today there are more females involved in the arts than males. Women are consistently winning top honors in regional as well as national competitions.

It was my pleasure to review the entries to this important exhibition. While I was disappointed that we had to disqualify some very good work because size restrictions were not followed,

I was more than impressed by the overall quality of most entries. My selections embraced a variety of styles, subjects and media. Be it abstract, non-objective or photo-realism, the criterion in my judgment is always a combination of craftsmanship, creativity, interesting shapes and colors, plus strong composition. But above all else, I look for a piece where the artist has somehow managed to instill into the work a spirit or life of its own. That doesn't happen very often but when it does, it is a joy to see.

Billy Morrow Jackson
Central Region
I felt after judging a regional section of the larger statewide show that central Illinois women artists are well represented. In judging the work I was not concerned so much with the isms or directions of the artists but rather the qualities of what they presented — the conviction, expression, mood and performance. With that in mind, I believe I selected a variety of work that encompasses the quality and range of women artists working in central Illinois.

Debra K. Tayes
Southern Region
It is with great satisfaction that I have had the opportunity to be one of the jurors in the state-wide search for current work by Illinois women artists. As the juror for southern Illinois, I found myself challenged and stirred by the broad variety of work submitted. Several entries went beyond the categorical framework of the "call for entries," revealing that women in Illinois are working in a wide-ranging variety of media. My selection of the work was largely based on originality, technicality, pre-

sentation, and my initial reaction to the piece; all of these enhanced, of course, by the quality of the slide.

After I completed my selection process, I had the chance to preview most of the work from across the state that was selected for the exhibition. Both individually and as a group, the artists — young and old — displayed a healthy sense of confidence and intrigue. I realized that, as the exhibition tours the state and visits the nation's capital, these pieces together represent a mark in time as the new millennium approaches, and it imbued me with a sense of history.

I find myself looking forward to viewing all of the work in a gallery setting. Again I am challenged to study the emerging themes, the messages, the sensibilities, and the imagery and ideas. I also wonder what their relevance will be to the contemporary art world at large.

The whole project has much to offer. It would not have been possible without the initiative of a few who grew it into a whole. Those people are sincerely appreciated.

SUPPORT

This program is partially supported by a grant from the Illinois Arts Council, a state agency.

Gold Benefactor	**Marshall Field's**	INDECK Energy Services, Inc.
	Target Stores	McDonalds Corporation
	Aon Corporation	Sears
	AT&T	State Farm Insurance Companies
Silver Benefactor	Meta S. and Ronald Berger Family Foundation	Bruce Wirtz MacArthur
	The John Buck Company	Material Service Corporation
	William Charles, Ltd.	Mitsubishi Motor Manufacturing of America, Inc.
	The Crown Family	Esther P. Schwartz
	Cullinan Companies	
Bronze Benefactor	Judy Bartholf	Lucent Technologies
	Virginia Bobins	Claire F. Prussian
	Browning Ferris Industries	Christine A. Quaini
	Kathleen A. Carpenter	Carol A. Reitan
	Citizens for Jim Edgar	Verne and Cynthia Scazzero
	David Coolidge III	Patricia Shafer, Sr.
	Lois Coxworth	Jennifer Sifton
	John and Sue Duffy	Ellen M. Simon
	Everen Securities	Southern Illinois Cultural Alliance/Rend Lake College/Illinois Arts Council
	Daniel B. Haight	Office of the Chancellor, Southern Illinois University, Carbondale
	Justine Jentes	
	The Kasser Art Foundation	
	Norma and George Kottemann	School of Art and Design, Southern Illinois University, Carbondale
	Georgia Lloyd	
	John A. Logan College, Museum & Art Galleries, Cartersville	Daryl Gerber Stokols
Committee of 1,000	R-Lou Barker	Christy Hefner (Playboy Foundation)
	Meta S. Berger	Beatrice C. Mayer
	Carlotta Bielfeldt (Bielfeldt Foundation)	Claire F. Prussian
	Rosemarie Buntrock	Esther P. Schwartz
	Marilyn Mason Cagnoni	Patricia Shafer
	Catheleen Kahn Healey	Barbara A. Trautlein
In Kind Donations	Illinois State Museum:	Nick and Marilyn Mason Cagnoni
	Dr. R. Bruce McMillan, Director	Michael A. Dunbar
	Kent Smith, Director of Art	Filson/Gordon Associates, Springfield, Illinois
	Estie Diane Karpman, Development Director	Justine Jentes
		Arlene Rakoncay, Executive Director, Chicago Artists' Coalition
	Sylvia Arnstein	Art Smith & Company, Inc.
	Ronald and Meta S. Berger	Jacqueline W. Vlaming

Thank you to all Illinois members of NMWA who donated up to $99 and whose names are too numerous to list here.

**The Illinois Committee
for the National Museum of
Women in the Arts**

Honorary Chairman
Lura Lynn Ryan

Honorary Co-Chairmen
Loretta Durbin
C. Nina Fitzgerald
Maggie Daley
Brenda Edgar
Jeanne Simon

President
Charlotte Arnstein

Vice-President
R-Lou Barker

Secretary
Joan J. Miller

Treasurer
Verne Scazzero

Board Members
Sylvia Arnstein
Judy Bartholf
Meta S. Berger
Alexandra Mochary Bergstein
Marilyn Mason Cagnoni
Grace Cole
Ronne Hartfield
Catheleen Kahn Healey
Lesley Killoren
Dale Osterle
Cynthia Scazzero
Susan Weininger

Attorney
Kristin Solberg
Novak, Weaver & Solberg

Catalogue Committee
R-Lou Barker, Chair
Sylvia Arnstein
Cynthia Scazzero

Design
Jeff Stasik
Stasik Design Corp.

Exhibition Committee
Dale Osterle, Co-Chair
Susan Weininger, Co-Chair

EXHIBITION CALENDAR

ILLINOIS ART GALLERY/ILLINOIS STATE MUSEUM
Chicago, April 23 – July 30, 1999

THE NATIONAL MUSEUM OF WOMEN IN THE ARTS
Washington, D.C., September 9 – December 12, 1999

THE LAKEVIEW MUSEUM OF ARTS AND SCIENCES
Peoria, January 14 – March 20, 2000

SOUTHERN ILLINOIS ART GALLERY
Rend Lake, June 10 – August 13, 2000

THE GALLERIES, ILLINOIS STATE UNIVERSITY
Normal, September 19 – October 29, 2000

ILLINOIS STATE MUSEUM
Springfield, November 19, 2000 – January 28, 2001

ROCKFORD ART MUSEUM
Rockford, February 16 – April 22, 2001

PARKLAND ART GALLERY
Champaign, May 17 – June 22, 2001

QUINCY ART CENTER
Quincy, July 13 – August 17, 2001

Video Available

Illinois Women Artists: The New Millennium is a 27-minute documentary which offers a rare and valuable insight into the lives and work of many of the participating artists. We see these artists in their studio as they discuss their work, and we watch the final jurying process, followed by the gala opening at the Illinois Art Gallery/Illinois State Museum in Chicago on April 23, 1999. Produced by Shuli Eshel Productions. Available through Shuli Eshel Productions, 3600 N. Lake Shore Drive, No. 1205, Chicago, Illinois 60613 (773/868-4140), and at exhibition sites.